SENATOR

In the Company of
CONNIE MACK
U. S. Senator from Florida

Written and photographed by
RICHARD SOBOL

Foreword by Connie Mack

Government in Action Series

COBBLEHILL BOOKS
Dutton/New York

For Daniel

Library of Congress Cataloging-in-Publication Data

Sobol, Richard.
 Senator : in the company of Connie Mack, senator from Florida / written and
photographed by Richard Sobol ; foreword by Connie Mack.
 p. cm.—(Government in action series)
 ISBN 0-525-65197-7
 1. Mack, Connie, date. 2. United States. Congress. Senate—Biography—
Juvenile literature. 3. Legislators—United States—Biography—Juvenile
literature. I. Title. II. Series.
 E840.8.M23S63 1995
 328.73'092—dc20
 [B] 94-33076 CIP AC

Published in the United States by Cobblehill Books,
an affiliate of Dutton Children's Books,
a division of Penguin Books USA Inc.,
375 Hudson Street, New York, New York 10014

Designed by Charlotte Staub
Printed in Hong Kong First Edition
10 9 8 7 6 5 4 3 2 1

FOREWORD

When Hurricane Andrew, the worst hurricane disaster in U.S. history, tore through south Florida in 1992, the destruction was devastating.

While Andrew was a testimonial to the strength of Mother Nature, the nationwide relief effort and reconstruction was a testimonial to the human spirit of perseverance and hope.

Thousands of people, all across America pitched in to send food, clothing and medical supplies to those who were affected by the hurricane; it was an emotional and uplifting display of our great American tradition of neighbor helping neighbor.

There's no question that government responded to Andrew's destruction. But the truly inspirational examples of service didn't come

from Washington. They came from volunteers in towns, churches and schools all across America who wanted to help people whose lives were changed by the hurricane.

And that is America's greatness.

As you read this book and look at the photographs, I hope you'll recognize that you don't have to be a Senator to make a difference. You can serve others right where you are.

We should all be ever thankful that we live in a nation that values freedom because freedom is the core of all human progress. It's a blessing we must never take lightly.

Our freedom allows us to pursue dreams, work hard and help others in their time of need. As long as you have hope that you can make a difference, you can accomplish anything.

Connie Mack

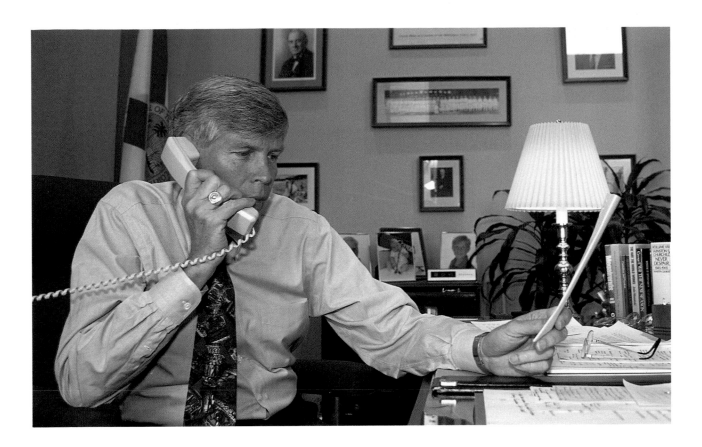

As far back as 1900, there was a famous Senator in Washington, D.C., named Connie Mack. But his uniform was the chest pad and face mask of a catcher playing professional baseball on a team called the Washington Senators. This Connie Mack became known as Mr. Baseball, and earned a place in the Baseball Hall of Fame. As manager/owner of the Philadelphia Athletics for fifty years he won five World Series.

It would be two generations later before Washington would have another Senator with the name Connie Mack. Today, Republican Connie Mack represents the state of Florida in the U.S. Senate.

The decision to enter politics was not made by Connie Mack III early in his life. As a child he knew about fame and recognition, having

shared the name of his grandfather, the baseball legend. He preferred a more quiet life and became a banker and businessman, comfortable with his family, involved with his community in Cape Coral, Florida. He was on the board of directors at the community hospital and contributed to neighborhood charities.

Things changed when his younger brother, whom he regarded as his best friend, was diagnosed with skin cancer that would prove to be fatal. This turn of events radically changed Connie Mack's life.

For thirty days, Connie Mack camped out in his brother's hospital room. Together they talked for hours about what life meant to them.

"Michael's illness and death really hit me hard. It forced me, for the first time, to really press myself to answer the basic questions of life: What is its purpose and meaning? That thirty days, being with somebody that I loved and respected so much—and seeing him die at the age of thirty-five—that gave me pause to reassess my life. It forced me to want to do better. I asked myself, am I using my God-given gifts to the greatest extent that I am capable of, and the answer that I heard back was no. The thing that I learned through Michael's death and the struggle to answer those basic questions was that helping other people—was the most satisfying activity that I could be involved in and that government was the place for me to do that."

And so, in 1982 at the age of forty-two, looking to find meaning in the death of his brother, Connie Mack entered the world of politics. He was elected first to the U.S. House of Representatives where he served three terms before winning a seat in the U.S. Senate in 1988.

The loss of his brother has had a strong influence on Connie Mack's work as a United States Senator. He has become one of the leaders in pushing for legislation that will increase the availability of medical testing to detect cancers early in their development. This could save lives and spare other people the pain that his brother went through.

The bill that Senator Mack has introduced, the Mack/Breaux Cancer Screening Initiative (cosponsored by Senator John Breaux, of Louisiana) is designed to help offset the high costs of medical exams. This bill encourages prevention and would seem to be something that would get quick Senate approval, but the wheels of government move slowly and cautiously. While something may appear to be a good idea, that does not necessarily mean that it will automatically become government policy.

The week I accompanied Connie Mack to Washington, D.C., started with an intensive push for the Cancer Screening Initiative. Early on a Monday morning the Senator was driven to ABC's television studio for an interview on "Good Morning, America" to discuss a special Senate hearing that he had arranged to highlight the importance of cancer detection programs.

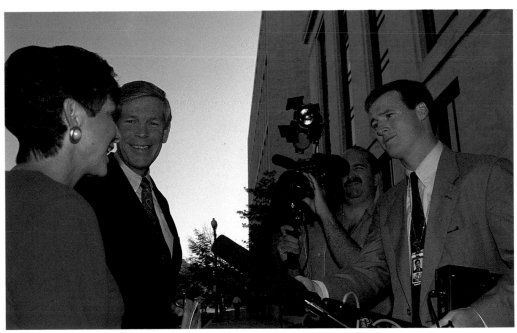

Meeting with reporters outside the hearing for the cancer screening bill.

This national exposure would be important as a way to generate publicity and information that might help persuade other Senators to vote for this bill. The scheduling of this interview had changed three times during the night as news of an attempted takeover of the Russian government became the major story. This news has delayed the timing of the interview but it has also increased the number of people tuned in to TV news this morning, which is good for the message that Senator Mack is hoping to share.

"Because of this news in Russia we might have one more person watching who will think to get a checkup today. And maybe that person will live a few years longer because of that."

After the TV interview, already running late for the start of the Senate hearing, the Senator pulls up to the Dirksen Senate Office Building and is met by a curbside gathering of TV cameras, lights, and microphones. He is accompanied by his wife, Priscilla, and Linda Gray, an actress from the TV series "Models, Inc.," both of whom have had personal encounters with cancer and will be the first to testify.

Many serious matters in Washington do not attract attention and press coverage unless celebrities lend their names to the cause. It is now a common practice to invite a famous actor or actress to testify before the Senate and help generate publicity. Senator Mack's press secretary had told me in advance about the expected appearance of Linda Gray, and he proudly added, "She is *our* celebrity."

Although the hearing is due to start in one minute the Senator stops to talk to the press. The cancer hearings are at the top of his agenda, but the press questions are about the situation 3,000 miles away in Moscow. "Yes, I'll talk about Russia," he says politely, "but we have to talk about these hearings as well. Is it a deal?"

After a few minutes of questions a nervous press aide steps in to

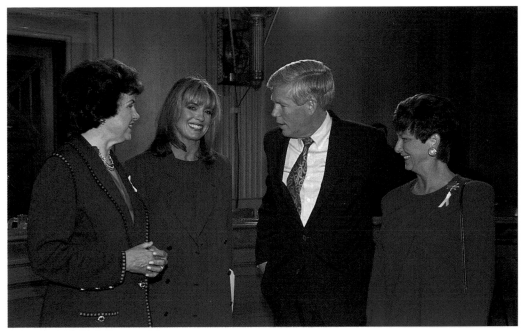

Senator Dianne Feinstein, actress Linda Gray, Senator Connie Mack, and Priscilla Mack.

move the Senator along. "We must be going, Senator," he says. The reporters ignore this and keep on asking questions. "We must be going, Senator," the aide pleads again.

Finally, Priscilla Mack grabs her husband by the arm and says, "Come on, Connie, Senator Feinstein is waiting." Senator Dianne Feinstein, Democratic Senator from California, is the cochair of the Senate Cancer Coalition and is working closely with Connie Mack on this issue. Like so many in the Senate, it crosses over political party lines.

"The Senate is a small group and we have to work together for years to come. Because there are only one hundred of us, you can get to know people here on a one-to-one basis. Republicans and Democrats. Sometimes the discussions and votes may seem nasty or rough. The most important rule for survival is NEVER

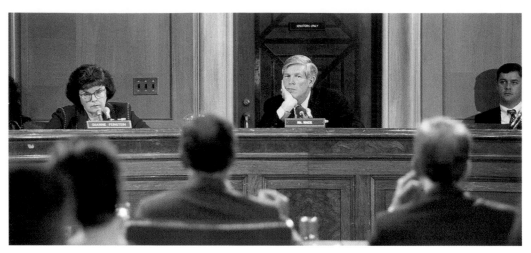

Dianne Feinstein and Connie Mack at hearing.

to take things personally. Political debates are like sporting events. You can watch two football linemen pound each other for sixty minutes and then when the game is over they will pat each other on the backs and go out to dinner."

Five TV news cameras are in place to record the hearing today, as well as an official secretary from the Senate who will transcribe the session into a published record. Every word becomes part of a permanent archive called the *Congressional Record*. The hearing also is sent around the country via cable TV where the information is available to anyone wishing to tune in.

Statements from the two Senators lead off the proceedings which continue for five hours as nineteen witnesses, including doctors, nurses, researchers, cancer survivors, and hospital directors all give their expert opinions. The words are a mesh of personal stories, technical information and reports on statistics that occasionally turn into long drawn-out speeches. Senator Mack, displaying great stamina, stays alert throughout all of this, interjecting questions and comments with focused attention.

At 12:30 Senator Feinstein finally gets up and apologizes that a group from California is expecting her and she must reluctantly move on. Audience members come and go, the press slowly filters out through the heavy bronze doors and staff members disappear in search of coffee. By now only a few people remain. Senator Mack sits alone behind the long circular desk as he listens to the last few witnesses who have donated their time to speak in Washington.

"These people have something important to say and I want to hear it. They deserve my attention," he says standing up for the first time in many hours. He turns to the door at the rear of the room marked, Senators Only, and walks slowly before stopping once more and smiling as he says, "And . . . now I need the Rest Room," a comment that brings a welcome laugh to the few staff members and technicians who remain behind. This gentle touch of humor helps to put people at ease again. This skill has served Connie Mack well in the U.S. Senate and earned him the friendship and respect of his colleagues, regardless of whether or not they agree on political philosophies.

Connie Mack remains at the hearing until the end.

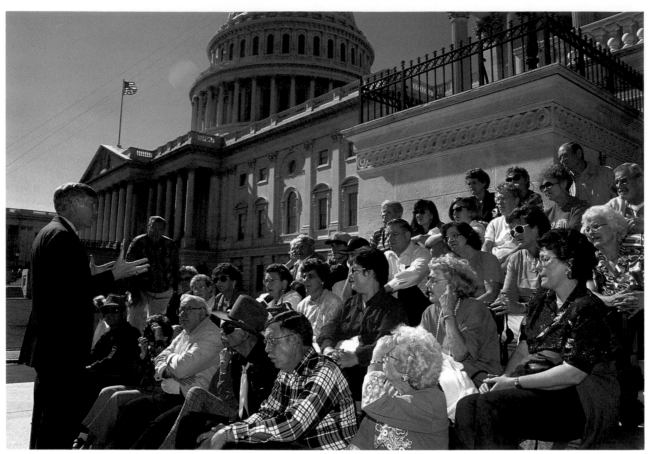

Meeting with Florida residents in Washington.

The work of a United States Senator is centered in Washington, D.C., where laws and policy are shaped and debated, but the Senators work for the people in their home states. For Connie Mack the people of Florida are always present in his mind. They are the ones who elected him to be their representative and they will have the power to re-elect him again at the end of his six-year term or send him out job hunting. Throughout the day he and his staff of fifty-four will be in touch with hundreds of Florida citizens who have questions or need government assistance. Most weekends find him boarding an airplane for one of his regular commuting trips back to Florida.

When the Senate is in session Senator Mack usually starts the day at six in the morning with a three-mile run, as the sun rises over the Capitol. After a quick breakfast he will walk the three blocks to his office in the Hart Senate Office Building and meet with his staff to go over the news of the day and discuss the variety of issues he will be dealing with. Planning the day's meetings is always the main item on the agenda. Committee meetings in the morning, lunch meetings to discuss an issue, scheduling meetings, afternoon hearings, Appropriations Committee meetings, meetings with visitors from Florida, meetings with people about specific legislation, and late afternoon meetings with other Senators. Sometimes he may have as many as eighteen or twenty meetings before he leaves his office to attend one or two evening receptions.

Throughout much of the day, Senator Mack moves around Capitol Hill alone, without staff, files, or even a briefcase. There is no big entourage. Referring frequently to the printed schedule folded up in his coat pocket, he is usually greeted at each new location by one of his aides who fills him in on the background of the meeting or hands him a speech or stack of briefing papers to read over.

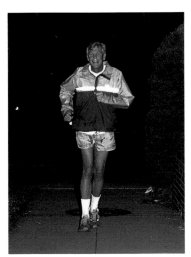

Enjoying his three-mile run.

Meeting with his staff in his office.

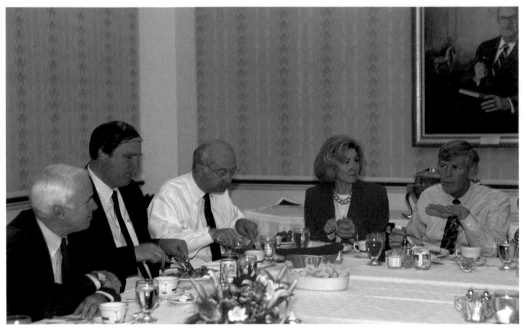

Republican Senators lunch meeting with John McCain, Bob Smith, Phil Gramm, Kay Bailey Hutchinson, and Connie Mack.

The official schedule is only wishful thinking of how the day will turn out. When the Senate is in session, Senator Mack's day is not really his own. It is pushed and pulled by the calls to vote on the Senate floor. Throughout the Capitol—in hearing rooms, corridors, dining rooms, elevators, and subway cars—buzzers, bells, lights, beepers, and clocks alert Senators that they are needed on the floor of the Senate. Once the bell rings and the lights are illuminated a Senator has fifteen minutes to get to the floor to cast a vote. Meetings get interrupted, speeches get cut off, reporters get pushed aside, and phones get hung up as the Senators rush to the floor to have their votes recorded.

At those times throughout the day when votes are called, the Senate subway system, which connects the Senate office buildings to the Capitol building a half mile away, is reserved for Senators only. Staff or

tourists must walk or wait while the otherwise dignified Senators run toward the open trains.

Connie Mack has found his seat on the car and sees his colleague from Florida, Senator Bob Graham, and shouts, "Run, Bob, run. I'll save you a place." These two Florida Senators have a strong working partnership, despite the fact that Mack is a Republican and Graham a Democrat. In other states this is not always the case, as political rivalries sometimes create roadblocks that detour cooperation. Mack and Graham often make public appearances together and consult on how to get the most for Florida. The importance of this cooperative relationship was most noticeable in the weeks after Hurricane Andrew ripped through southern Florida in 1992. Together they pushed to get money quickly to assist the stranded and homeless. As the two staffs worked as one team in a cramped, makeshift office, Graham and Mack roamed the Senate floor, lining up the support needed to secure the Senate vote for emergency aid money.

"There is a question in politicians' minds as to what to do in the aftermath of

On the Senate subway.

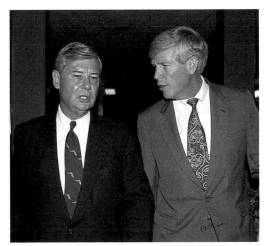
Connie Mack with Bob Graham.

a Hurricane Andrew or the earthquake in Los Angeles. You show up and there are all kinds of TV cameras, photographers, microphones, and reporters. I worry that the people out there who are in need and hurting might be thinking, 'Well there is that politician who comes down here for no other reason than to get his picture in the paper.' But it was clear to me in a very short period of time while walking through the rubble left by Hurricane Andrew that the role of the elected official is to physically reach out and hold somebody, to say look, we know that you are hurting and we haven't forgotten you. We are going to see that you get taken care of. I spent two weeks just going around south Florida, listening to people to find out what the problems were. Then I was able to come back to Washington and help to put together the appropriations packages to get the dollars to do the kinds of things that needed to be done. In this case it really made a difference."

Politicians in Washington are known (and often are the subject of jokes) for their special ability to find complicated explanations for

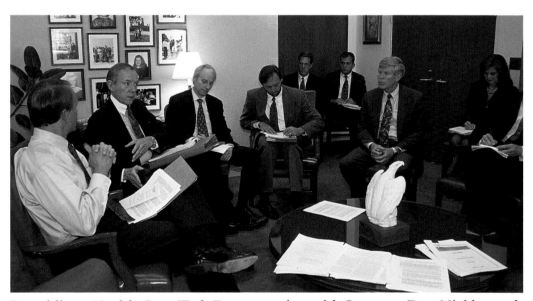

Republican Health Care Task Force meeting with Senators Don Nickles and Orrin Hatch.

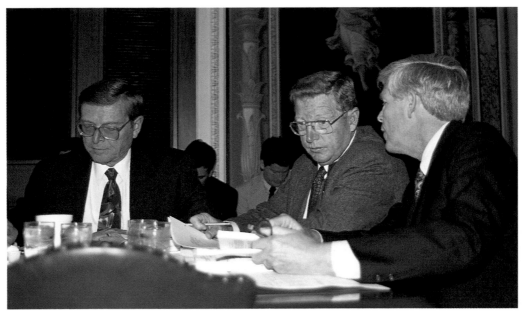

Appropriations Committee Meeting with Senators Pete Domenici and Conrad Burns.

things that are often rather simple. Connie Mack is attending a meeting of the Senate Republican Task Force on Health Care that has been working on a proposal for a new national health care plan. Mack and Senator Don Nickles of Oklahoma have a detailed outline which they are presenting to some of their colleagues in technical language that is not always easy to follow. Their fellow Senators seem lost in the avalanche of words. Senator Orrin Hatch of Utah, a friend and advisor, finally turns to Connie and says, "I saw you on TV the other night and you explained this as well as anyone that I know. But when you get down to all those details . . . it gets very fuzzy. Now let's put our heads together and try to say this in plain old American English."

Even when they are disagreeing or attacking each other in official Senate proceedings, Senators' statements all begin with polite praise.

Connie Mack is one of fifteen Senators meeting on the Senate Appropriations Committee which is responsible for dividing up huge sums of money that are funnelled throughout government agencies. Billions of dollars are being discussed here, and lots of companies and government agencies are working to get some of it. The discussion here will translate into money and jobs as each Senator focuses in to include the projects that are important to their states.

For an outsider listening to the discussion around the paper-strewn table it would be difficult to figure out what is really at stake here. Even arguments begin with words like, "My dear friend . . . ," or "My esteemed colleague."

"Image an incident on the Senate floor where another Senator was stepping on my toe and I had to react to this using the proper language of the Senate. Instead of just yelling, 'Get the heck off my foot!' I would have to say something like, 'I feel that it is my extreme duty to inform the learned members of the Senate, and in particular, my distinguished colleague, that he is doing this Senator great bodily harm at the present moment by standing with such force and weight on my toe. I wonder if my kind and gentle colleague would be gracious enough to please remove his foot to a more neutral location!'"

Connie Mack says that one thing that he loves about his job is that it never gets boring. While that may seem hard to believe while sitting through a five-hour hearing in Washington, it became completely clear while accompanying him on a three-day, 750-mile trip around Florida. Jumping from town to town and topic to topic, never repeating the same speech or hearing the same question twice. Over the course of three days he got to meet hundreds of Florida residents, report to them on his activities in Washington, and hear from them about their concerns.

While in Florida he is in constant motion, carrying his own bags into

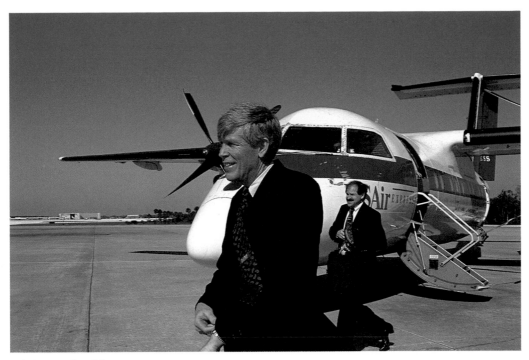

Visit to Florida.

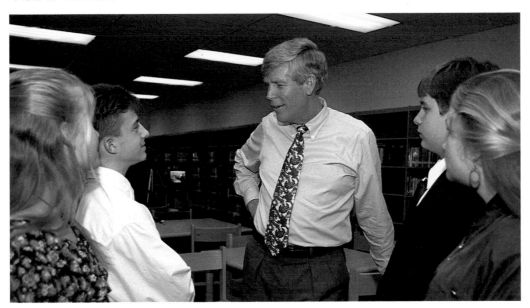

At Citrus Grove Middle School in Florida.

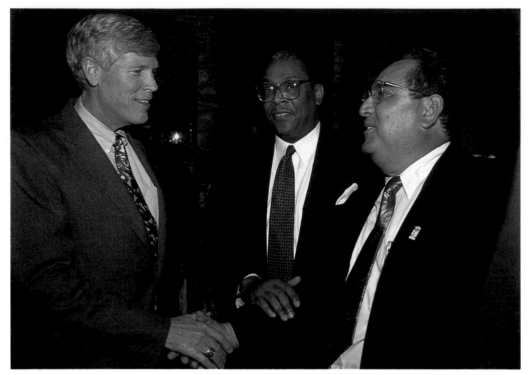

Being introduced to the Mayor of Managua, Nicaragua, in Miami.

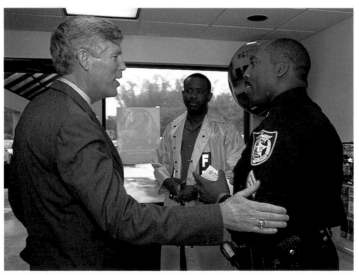

In Vero Beach, Florida. Connie Mack carrying his bags to the hotel.

a different hotel room each night, often arriving late and leaving at the first light of day. He moves through the state without any fanfare or fuss, appearing to be just another person going about their business or eating at a fast-food restaurant. When he is occasionally recognized by someone on the street or while passing through an airport he can't help but stop for a few minutes to chat.

During the course of one day in Florida, he will attend discussions on subjects ranging from health care, crime prevention, education, immigration policy, and environment. These topics are only a fraction of the concerns found in a state as diverse as Florida which includes large populations of elderly, Latino, Black, Jewish, high technology

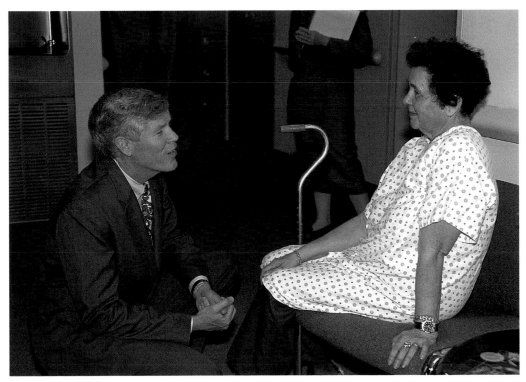

At Indian River Cancer Center.

workers, fishing industry, and Disney World. Each of these groups has questions for their U.S. Senator and expects him to be an expert on everything. And at each event, when it should be time to move ahead with the day's schedule, he will turn to his driver and say, "Wait, we have a few more questions here," as he struggles to satisfy everyone.

"My favorite part of this job is really the education. I have learned so much. I have been exposed to so many experiences that I would not have been exposed to had I not been involved with politics. There are over 13 million people living down here and sometimes I have anxiety that I am not an expert on every issue facing Florida, even though I am expected to be. My personality is such that I can't fake things. I have to know the issue, I need a lot of information, a lot of details. I know that I don't have all the answers, that maybe the other person's point of view might be right. I try to remember that I can learn more from listening to what others have to say than from talking."

It is said that there is no place in Florida where you are more than an hour away from the ocean. Much of the unique quality of life in Florida is dictated by the presence of water. Two of Florida's great water resources are now threatened by pollution and years of mismanagement. The Florida Keys and the Everglades National Park are in serious trouble and the survival of the thousands of varieties of plant, fish, and bird life that they nurture are threatened.

This is a problem that Senator Mack has been following since he first arrived in the Senate. Together with conservation groups like the National Audubon Society and the Nature Conservancy, he has been looking into ways in which the federal government can take action to turn around what appears to be the death of Florida Bay. Much of this week's visit to Florida is spent meeting with the people who are affected by this problem and observing the bay itself. There is a possibility that some people may have to be moved from their homes and relocated,

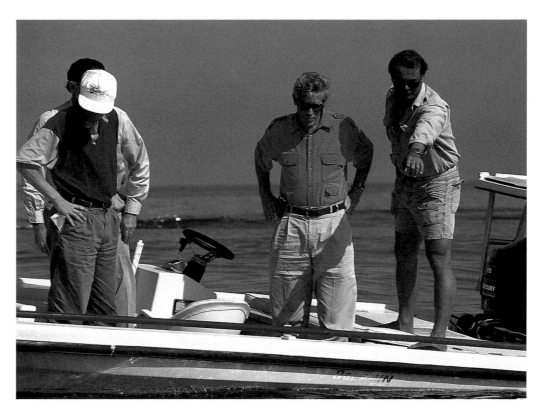

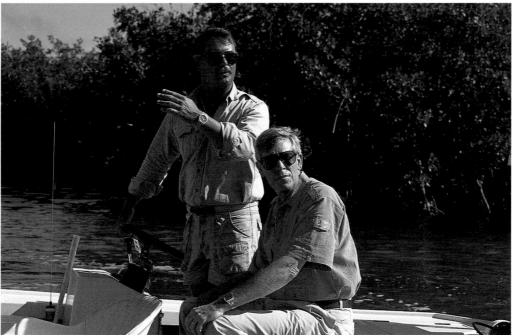

Tour of Florida Bay.

that the fishing industry may suffer for a while, and that some large sugar cane and tomato growers may have to reduce the amounts of fertilizers and pesticides that they pour into the ground. Not all of these groups are happy, some of them are angry and worried. Senator Mack is here to explain that the situation has become a crisis. Actions are going to be taken. After a day out on the water seeing the damage for himself he will be the lead speaker at The Everglades Coalition Conference in Miami, which will be attended by scientists, activists, and local residents who are desperate for help from Washington. Connie Mack will make many friends with the words that he will speak and possibly a few enemies as well.

"Yesterday I had the opportunity to go out onto Florida Bay and see what we are faced with here. We had one of the nicest days that anyone could ever have to go out on the water. The temperature was in the low 80s, there was hardly a cloud in the sky, not a ripple on the water. It was just a beautiful day. I felt the exhilaration of moving across the water at a fast speed, and the sense of freedom that one gets when enjoying nature. My feeling at first was 'What could possibly be wrong here?' But as soon as the captain pulled back from the throttle and that boat started to settle down into the water I looked over the side and I could not see the bottom, only four feet away. A gray cloud of algae lay below us. The sea grasses were all dead and the other marine life that should have been there were all gone.

"We know that one of the reasons that Florida Bay is in trouble is from a lack of fresh water. We understand that part of the science and biology. But there is another component here, the emotional part. When I look at the destruction that had taken place I thought about the beauty of the bay that I had experienced in the past, when the water was crystal clear and you could look down and watch the fish feeding on the bottom. Today when I look into that water the feelings that I have are of sadness and anger. That this has gotten to the point that we could

allow this to happen and that we still have to fight to convince people that we need to move forward to solve this problem. Well, you are not alone. This fight is my fight too."

The Senator's job after returning to Washington will be to shape his words and promises into legislation that will begin to turn things around in the Everglades. The first step in this process is to sort through the scientific data presented at the conference and blend that together with his own sense of urgency and outrage that he felt while looking down into the lifeless bay.

Leaving an evening reception chatting with Senator Alan Simpson.

Greeting an old friend en route to Joint Conference Meeting at the House of
Representatives.

There currently is a law called the Everglades Expansion Act that
sets aside money for flood control. Mack's idea is to take that money
(which has never been spent) and use it instead for land purchases
which will help to reduce the impact of development and farming on
the fresh-water table. The first step needed to make this come to life is
for Senator Mack, together with his staff, to explain this concept in

minute detail, and translate that into the language needed to express this in legislative form. Once the wording of the bill is acceptable they will approach other Senators to sign on as cosponsors, particularly Democrats, to show that this bill has wide support. After the cosponsors have lent their names in support, the bill will go to a committee for discussion. It is in these smaller forums that most of the debates over a specific piece of legislation take place. Senator Mack's goal is to get this bill to the Senate floor for approval by "unanimous consent" which means that 100 percent of the Senate has voted in favor of it. Any

With Senator Orrin Hatch.

disagreements will get resolved during "mark up" sessions before this bill is presented on the floor to the full Senate for a vote.

To get this bill through the Senate, Connie Mack will invest hours of direct, one-on-one, contact with his Senate colleagues. Sometimes this contact is educational, discussing the merits of the issue, sending letters and making telephone calls to explain the importance of the bill. Sometimes it is personal. Meeting a colleague in a hallway, putting an arm around a shoulder, Connie Mack will ask directly for help, and if it is necessary, he will plead until he hears a fellow Senator say, "Okay, Connie, I'll do it for you." This bill, like many others, will become law not only because of its importance to the environment but also because of the goodwill and friendships that Connie Mack has developed in his years in the U.S. Senate. Even when everyone agrees on an issue the Senate still remains a group of one hundred individuals, torn by the politics and concerns of their home states. Bringing them together on any issue takes a special kind of skill. That is what it means to be an effective member of the United States Senate.

GETTING TO KNOW CONNIE MACK

What do you like to do for fun?
Read, ski.

What relaxes you the most?
Reading, listening to music.

What is your favorite junk food?
Haagen Dazs chocolate ice cream.

What are your favorite things to spend money on?
Books.

What is your favorite part of the job of Senator?
I can read a book and then call the author to talk about it.

What do you miss doing now that you can't do because you are a Senator?
Go sailing. There just isn't enough time.

What don't you miss?
Boredom.

What do your grandchildren call you?
Grampies.

What are your favorite movies?
Dances With Wolves, Driving Miss Daisy.

Who are your favorite movie stars?

Morgan Freeman, Kevin Costner.

What music do you listen to?

Classical, western.

What are your favorite books?

Wind in the Willows, Robinson Crusoe, Swiss Family Robinson.

Who are your best friends?

My high school friends from Ft. Myers, Florida, and my brothers, Dennis and Michael, until he died.

When you were a kid did you want to be a U.S. Senator?

I never even thought that I would be a Senator when I was an adult. Priscilla, my wife, would always say to me, "Connie, just what are you going to do when you grow up?"

What would you like to do next?

Get re-elected and do the best job that I can.

More Facts About the Senator

The Senator's legal name is Cornelius McGillicuddy III.

The name Connie Mack was an invention of sportswriters who tired of writing out Cornelius McGillicuddy, the original given name of the Senator's grandfather.

Number of votes per year: approximately 325.

Number of bills filed by the Senator: approximately 24 per year.

Number of bills cosponsored by the Senator: approximately 175 per year.

Number of pieces of legislation reviewed: approximately 1,000 per year.

Number of pieces of mail received in offices: approximately 3,500 per week.

Number of speeches given: approximately 10 to 12 per month.

The Senator serves on five Senate committees: Appropriations, Banking, Small Business, Joint Economic, and Housing and Urban Affairs.

In addition, he sits on the Senate Cancer Coalition, Congressional Cuban Freedom Caucus, Sunbelt Caucus, Middle East Peace Monitoring Group, Hispanic Task Force, Zero Capital Gains Tax Caucus, Senate Republican Health Care Task Force, and the American Cancer Society Foundation.

Travels approximately 5,500 miles each month.

Maintains a home in Washington, D.C., and in Ft. Myers, Florida.

Has six district offices throughout Florida, located in: Ft. Myers, Tampa, Miami, Tallahassee, Pensacola, and Jacksonville.

Senate salary: $133,600.00.

Budget for offices and staff is $1.9 million which covers expenses and staff salaries.

The Senator jogs three or four times each week and usually walks to and from work.

ACKNOWLEDGMENTS

Finding and staying on a path through the world of the U.S. Congress is quite a challenge. For their help in guiding me smoothly through this new world I am endebted to the staff of Connie Mack, particularly Mitch Bainwol, Chief of Staff, who sold the idea of this book to the Senator and kept the doors to the office open for me. Mark Mills, press secretary, helped with keeping the facts straight. In Washington, D.C., Greg Williams, Buz Gorman, Elizabeth Walker, John Reich, and Kevin Kolevar were valuable sources of information. John McReynolds, Ann Hamilton, and Javier Vazquez watched over me throughout Florida.

For helping me to understand how the Senate operates I thank Dan Hazelwood, Chris Mottolla, Doug Cahn, Bonnie Cronin, Jorge Arrizurieta, Peter Leharshhmont, P.J. O'Rourke, and Jon Buckley.

Special thanks to the Capitol Hyatt for hosting me in Washington, D.C., and the Hilton at Disney Village for hosting me in Orlando, Florida.

For the fascinating tour of Florida Bay I thank Captain Mike Collins and wait with him for the fish to return.

Harry Powell helped to remind me just how interesting the Florida Keys can be.

For their help with the text, general encouragement, food and lodging I thank Robert Weiss, Susan Chimene, Art and Betty Bardige, Josh Rubenstein, Jill Janows, Sharon Grollman, and Rosanne Lauer.

Connie and Priscilla Mack greeted with smiles when we first met and kept up those smiles throughout eight days of companionship. I am endebted to the Senator for his kindness and patience, particularly for his understanding as I asked him over and over, to explain to me again, just how a law is made.